BULLET IT!

ISBN 978-1-250-16650-0 (trade paperback)

Our books may be purchased in bulk for promotional,
educational, or business use. Please contact your local bookseller
or the Macmillan Corporate and Premium Sales Department
at 1-800-221-7945, extension 5442, or by e-mail at
MacmillanSpecialMarkets@macmillan.com.

First Edition: August 2017

10 9 8 7 6 5 4 3 2

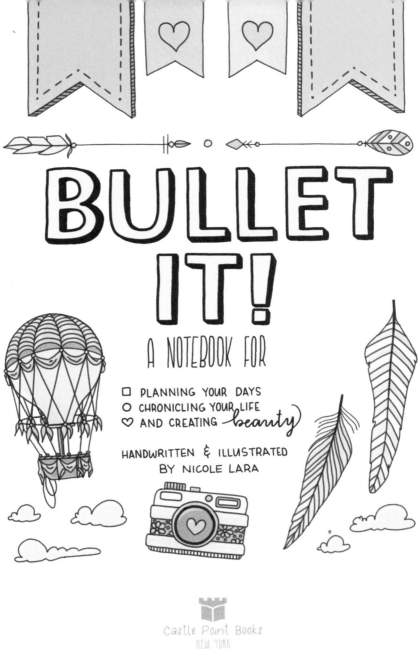

BULLET IT!

A NOTEBOOK FOR

- ☐ PLANNING YOUR DAYS
- ○ CHRONICLING YOUR LIFE
- ♡ AND CREATING *beauty*

HANDWRITTEN & ILLUSTRATED
BY NICOLE LARA

Castle Point Books
NEW YORK

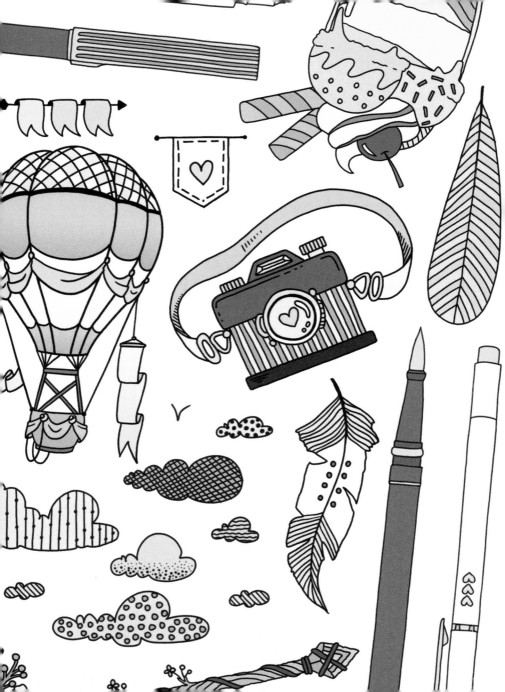

 # WELCOME!

I've written and illustrated this special notebook to create a fun and exciting tool for those who want to plan their lives, journal their days, or just express themselves through pen and paper.

I know a blank journal might be intimidating at first, so I've included my most famous doodling tutorials and doodle ideas I've come across during the time I've spent journaling in my notebook. I've also included some journaling prompts and tips on how to use the doodles and fonts shown. There is no right or wrong way to use this notebook, there is only YOUR WAY.

Based on what I've learned from using my own notebook as a creative outlet and a planning tool, I've included methods in this book to help you do the same. Use this information as a guide but don't limit yourself to this content only. I've learned a great deal about myself and how I am more productive by experimenting with various planning systems, so I encourage you to do the same.

Finally, I wanted to remind you that we all make mistakes and that it is OK if our creative and personal journey is not perfect. None of the doodles or illustrations I've drawn here are perfect, but they are unique in their own way and I really enjoyed drawing them. THAT'S WHAT COUNTS!

I'm sure you're eager to start using your notebook, so I shall not hold you up any longer. I hope this notebook serves you well.

With love,
NICOLE LARA

WHAT IS A PLANNING SYSTEM?

A planning system is a tool used to successfully plan and execute your goals and projects. Although the future can not be predicted, taking even a small fraction of time to create a map that will guide you through the best path possible is always a good idea. The best planning system is one that concentrates on daily action, focusing on making sure you take small steps that get you to where you want to go one day at a time.

having a goal in mind

Even though I encourage you to concentrate on daily planning and action, it is important to have a final goal in mind. Therefore, you should define an end point and work to create an action plan that will take you there. This action plan should give you a constant sense of reward with every milestone you accomplish.

CONCENTRATE ON DAILY ACTION

The best way to enhance your productivity level is to focus on daily actions. To get the best out of your days, it is advisable to create a plan the morning of or the night before the day. To create a daily plan, you'll need daily to-do lists. To create functional to-do lists, you must break down your big projects into tasks that you know you can do in one day or X period of time within that day. This way you're making sure to never overschdule or to fill to-do lists of tasks that are impossible to complete on the dame day. Effectively doing this will take practice, so don't get frustrated when you find yourself with an impossible to-do list at the beginning. Just take note on how you can create a better list the next day and keep moving forward.

Don't be afraid to change your planning style if it's not working. The best way to improve is to be conscious about our mistakes and to correct them as soon as possible. If a part of your system is not proving to be useful in your personal journey, review it, tweak it and try again.

To quickly recognize tasks in a to-do list, I use symbols and/or colors to classify each task into a category I created previously.

For example, one of the categories I created is "work." Any task related to my work has the same symbol at the beginning and uses the same color. How detailed you want to go with a coding system depends on you and how easy it is for you to keep up with it. If it's too difficult to maintain, you most likely won't be able to use it for a long period of time. Do your best to keep it simple.

Using a tracking system is optional, but it can be really rewarding and can give you information on your daily habits and behavior. Tracking your progress will help to keep you motivated and will allow you to know where you are. Some people might find it cumbersome to do it, while others need it to be able to keep up with their plans. Something as simple as listing the tasks/habits you're tracking and setting X amount of days to track it for is enough. You can also use an app on your phone to do this if it becomes tedious to do it in your notebook.

MY SYMBOL AND COLOR KEY

- ☐ work
- △ personal projects
- ○ study/reading time
- ♡ errands + appointments
- ♡ fitness + self-care
- • subtask or task breakdown

completion

☐ △ ○ ♡ ♡ ╱ 50%
☐ △ ○ ♡ ♡ ✗ 100%

TRACKING SYSTEM

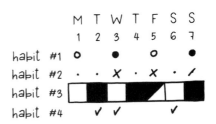

	M	T	W	T	F	S	S
	1	2	3	4	5	6	7
habit #1	○		●		○		●
habit #2	·	·	✗	·	✗	·	╱
habit #3							
habit #4		✓	✓			✓	

A planning system should always work FOR YOU, not the other way around. Taking out what is unnecessary will you to better focus on what is really important for you.

DREAM BIG,

set goals,

AND TAKE ACTION

dream

FONT #1

ABCDEFGHIJKLMNOPQRSTUVWXYZ

ABCDEFGHJKMPRWYZ

0123456789 × 3456789

THE BEST WAY TO PREDICT THE FUTURE IS TO CREATE IT

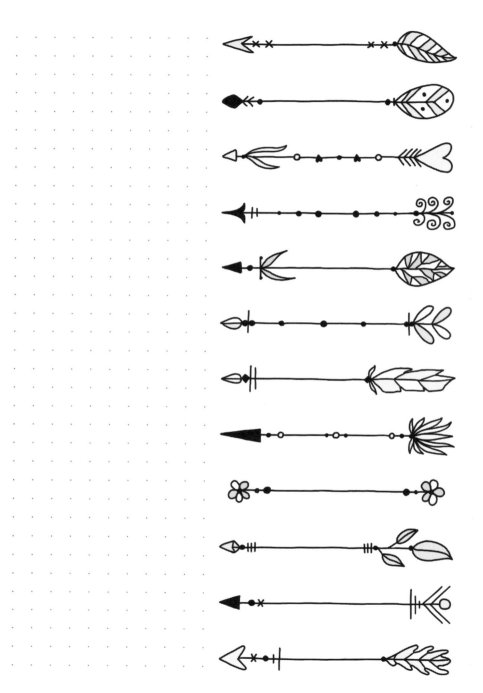

TAKE A SHOT AT YOUR TASKS WITH THESE ARTSY ARROWS

USE THESE ARROWS TO DECORATE YOUR JOURNAL ENTRIES,
HIGHLIGHT IMPORTANT INFORMATION, MAKE BEAUTIFUL TITLES
OR AS BORDERS / DIVIDERS.

FONT # 2

ABCDEFGHIJKL
MNOPQRSTUVWXYZ
0123456789

THE WORST ENEMY TO CREATIVITY IS SELF-DOUBT

— SYLVIA PLATH —

WHAT IS STOPPING YOU FROM ACHIEVING YOUR DREAM?

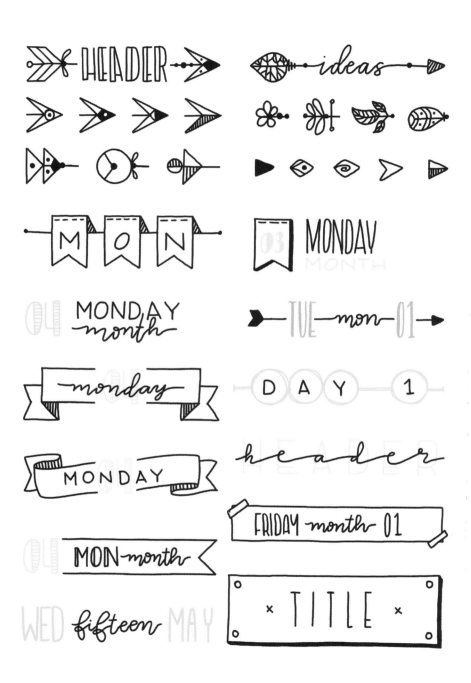

use these header ideas to
label your daily entries

font # 3

a q
b r
c s
d t
e v
f u
g w
h x
i y
j z
k
l 0
 1
 2
m 3
 4
n 5
 6
o 7
 8
p 9

If

there is

NO STRUGGLE

there is

NO PROGRESS

— FREDERICK DOUGLASS

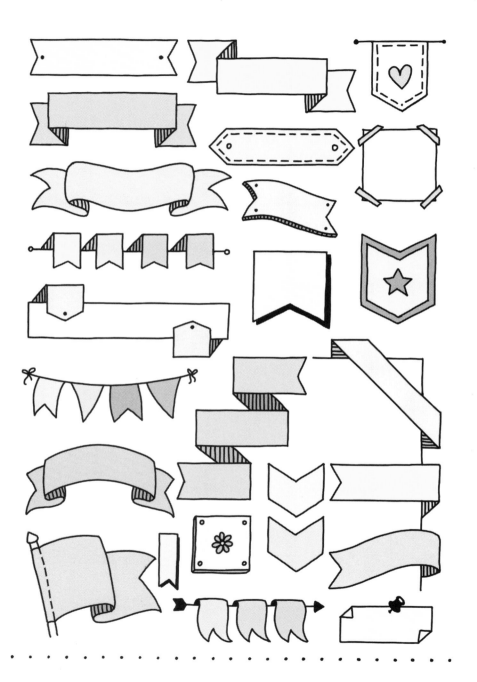

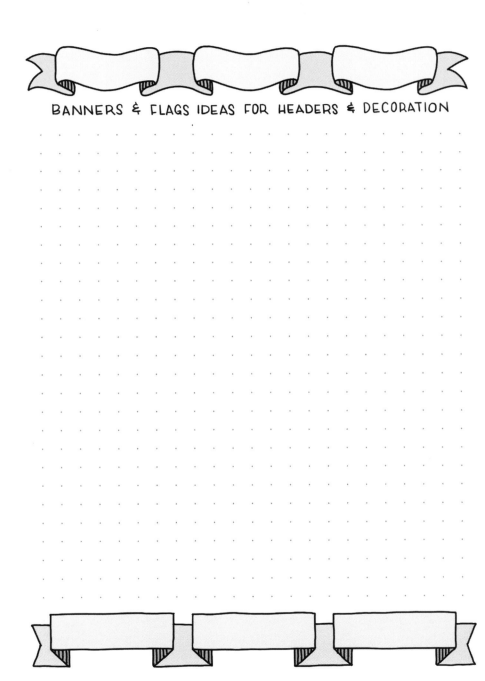

BANNERS & FLAGS IDEAS FOR HEADERS & DECORATION

HOW COULD YOU OVERCOME YOUR WEAKNESSES?

font #4

abcdefghi
jklmnopqrs
tuvwxy z

0
1
2
3
4
5
6
7
8
9

IF you get TIRED learn to rest, not to QUIT

HOW CAN YOU USE YOUR STRENGTHS TO IMPROVE YOUR LIFE?

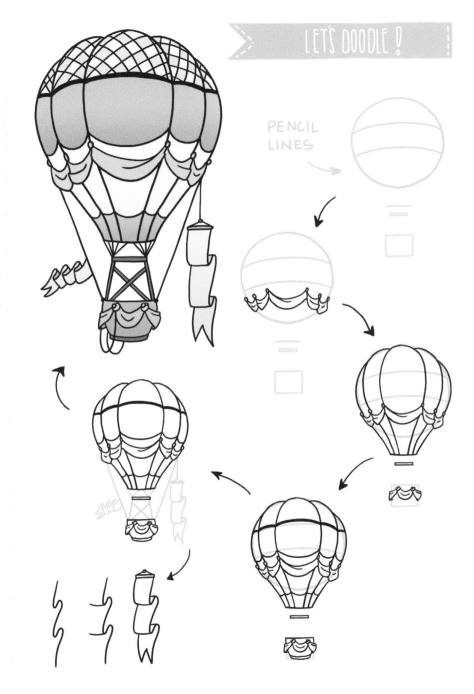

PENCIL
LINES

WRITE A DAILY ACTION PLAN TO REACH A GOAL YOU'VE BEEN PUTTING OFF FOR A LONG TIME.

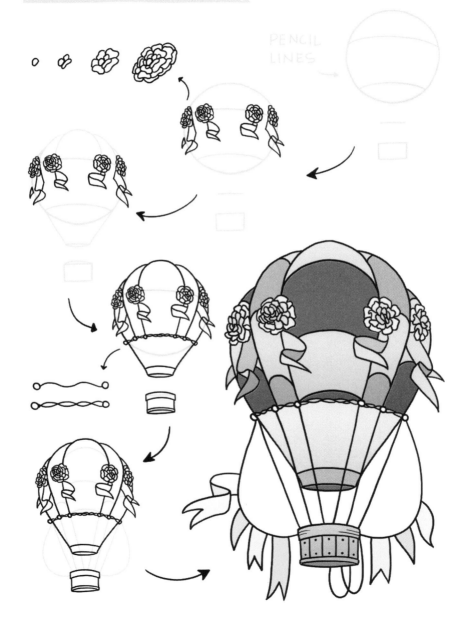

LET'S DOODLE !

PENCIL
LINES

LIST THINGS YOU'VE ALWAYS WANTED TO LEARN AND HOW YOU COULD START LEARNING THEM.

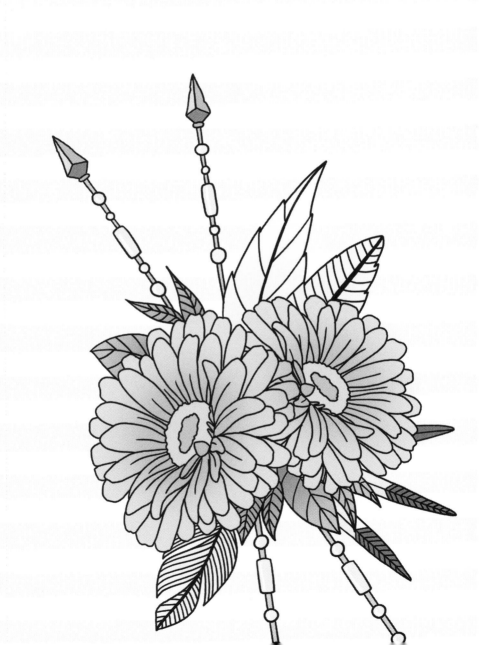

FOLLOW *your* HEART

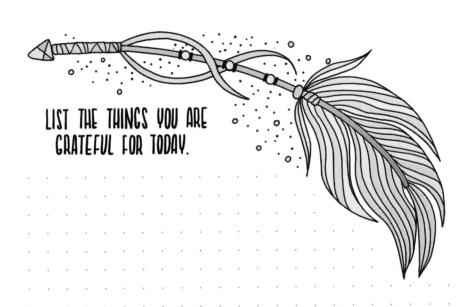

LIST THE THINGS YOU ARE GRATEFUL FOR TODAY.

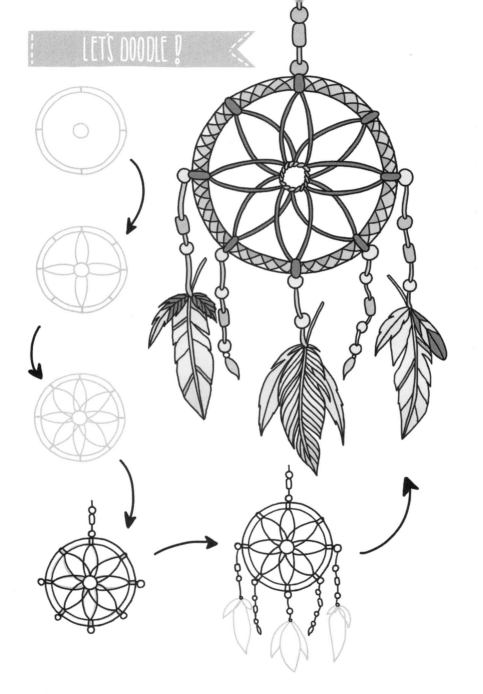

WHAT ARE YOUR FAVORITE THINGS IN LIFE? WHY?

WHAT DO YOU FEAR THE MOST? WHY?

WHAT TYPE OF FRIEND DO YOU WANT TO BE ?

capture

EVERY

moment

like

IT'S THE

last

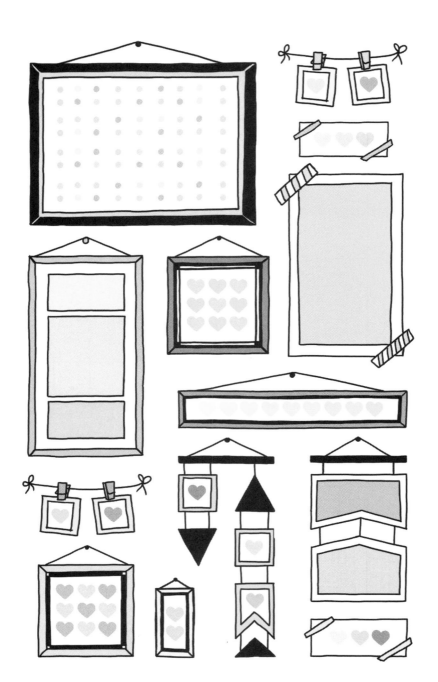

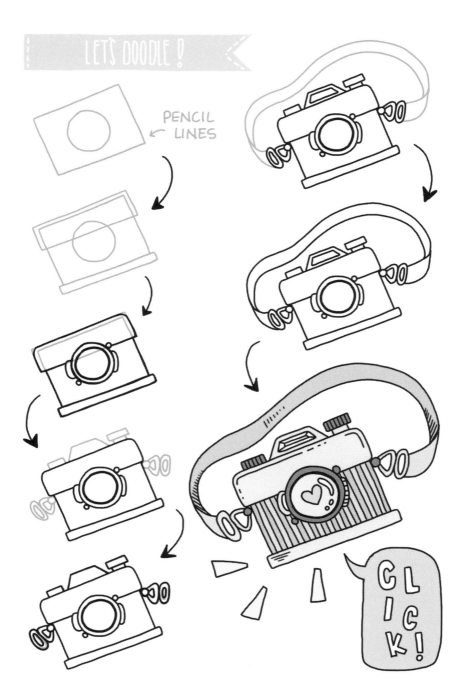

PENCIL
LINES

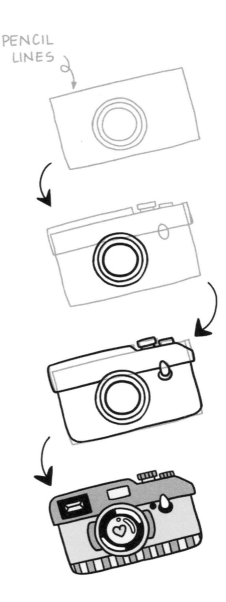

PENCIL LINES

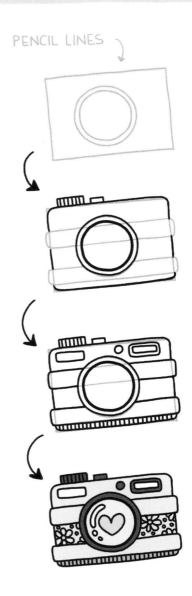

WHAT DO YOU VALUE THE MOST IN LIFE? WHY?

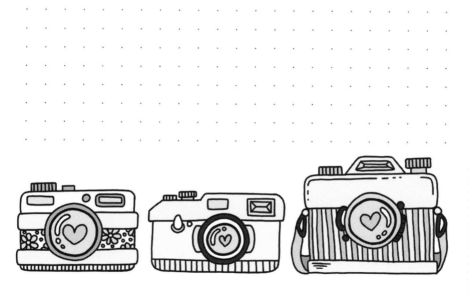

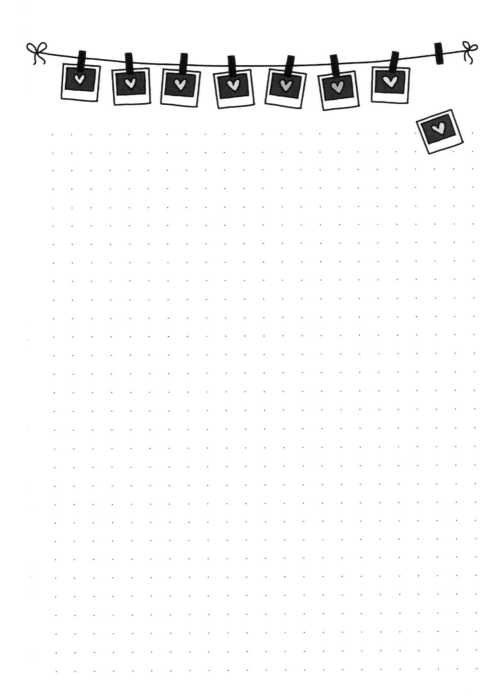

LETS DOODLE !

← PENCIL LINES

WHERE DO YOU SEE YOURSELF IN 10 YEARS?

PENCIL
LINES

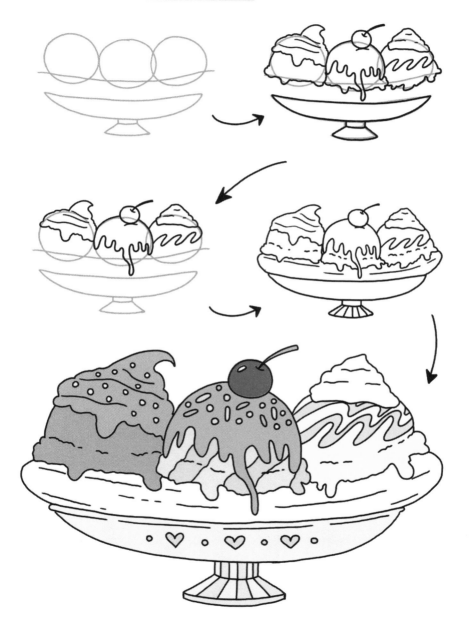